Color By Numbers Coloring Book for Adults
Nice Little Town

ZenMaster Coloring Books

Copyright © 2017 by ZenMaster
All rights reserved. No part of this publication may be reproduced, distributed, or transmitted in any form or by any means, including photocopying, recording, or other electronic or mechanical methods, without the prior written permission of the publisher.

Helpful Tips for Coloring

~ Sometimes the colors appear differently on paper than what you would expect. Use the color test page to play with your colors beforehand.

~ If you are using colored pencils make sure to keep them sharp. This helps when coloring smaller areas or details on the page. Fine point sharpies also work great for smaller areas.

~ Speaking of sharpies, make sure you put a scrap piece of paper behind the page you are coloring to keep the markers from bleeding to the next page.

~ When using crayons or pencils start out light. You can always go back and darken later.

~ There are so many tools for coloring: markers, sharpies, crayons, pencils, pastels, and the list goes on. Experiment with what works best for you and your designs. Though it's not necessary, using higher quality coloring utensils makes a difference.

~ If you come to a design that seems overwhelming just pick a place to start and go from there. Once you begin your creativity will quickly take over!! If you get discouraged just take a break and come back to the page later.

~ Remember to practice. Like anything else, the more you do it the better you'll get. It'll become more and more relaxing each time.

~ DON'T FOLLOW THE RULES! It's up to you how you color your designs. Just let your creativity take the lead and HAVE FUN!

COLOR TEST PAGE

COLOR TEST PAGE

1. Grey
2. Rouge
3. Grass
4. Cadet Blue
5. Island Red
6. Nude
7. Plum
8. Mystery
9. Coral
10. Stem
11. Cocoa
12. Milk Chocolate
13. Mocha
14. Light Yellow
15. Orange
16. Maroon
17. Penny
18. Sand
19. Honey
20. Olive
21. Fern
22. Dark Green
23. Fuchsia
24. Purple
25. Ballet Slipper
26. Rose
27. Punch
28. Sea Green
29. Rosewood
30. Periwinkle
31. Sedona
32. Bone
33. Aegean
34. Baby Blue
35. Dark Yellow

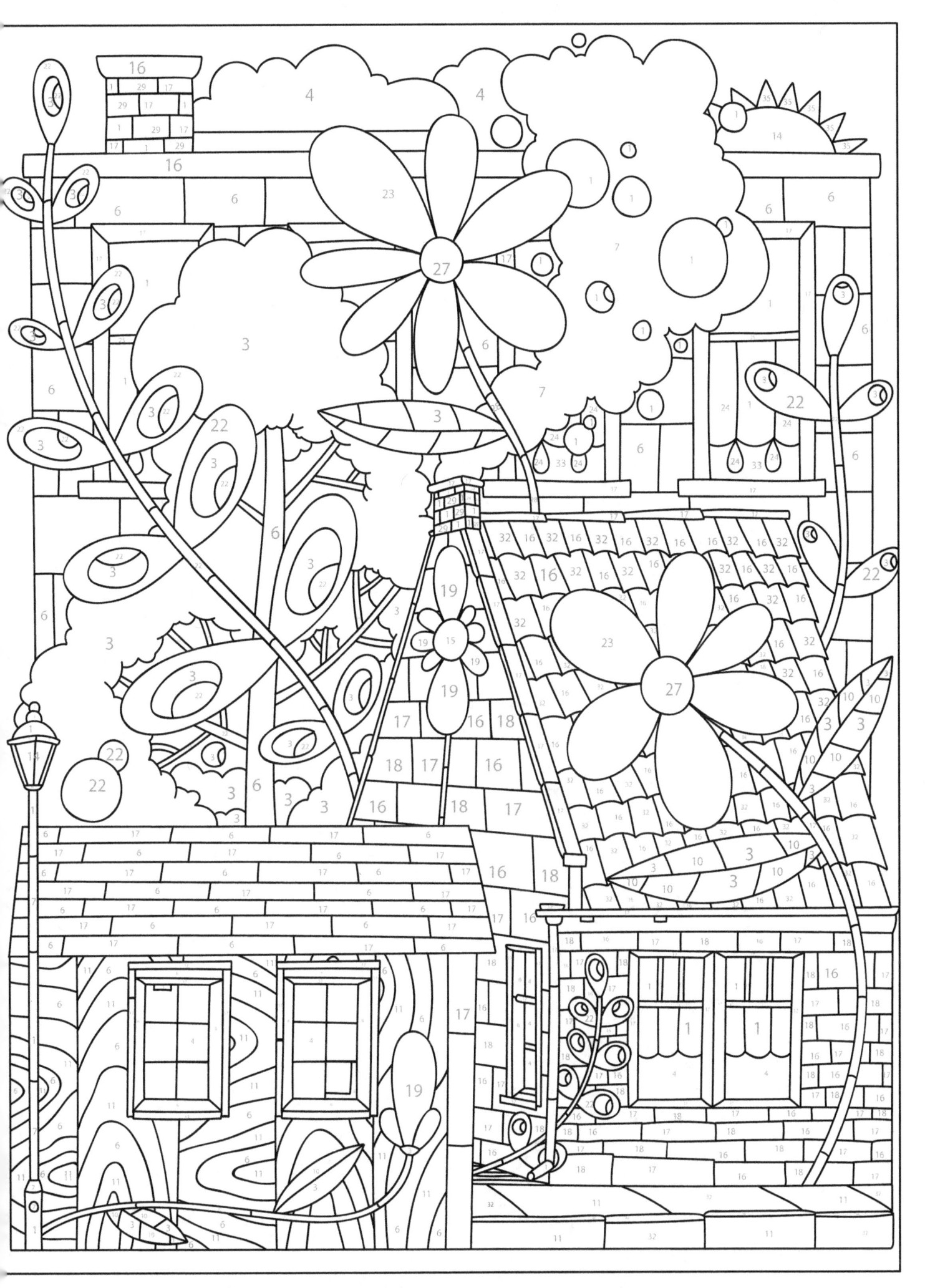

1. Grey
2. Rouge
3. Grass
4. Cadet Blue
5. Island Red
6. Nude
7. Plum
8. Mystery
9. Coral
10. Stem
11. Cocoa
12. Milk Chocolate
13. Mocha
14. Light Yellow
15. Orange
16. Maroon
17. Penny
18. Sand
19. Honey
20. Olive
21. Fern
22. Dark Green
23. Fuchsia
24. Purple
25. Ballet Slipper
26. Rose
27. Punch
28. Sea Green
29. Rosewood
30. Periwinkle
31. Sedona
32. Bone
33. Aegean
34. Baby Blue
35. Dark Yellow

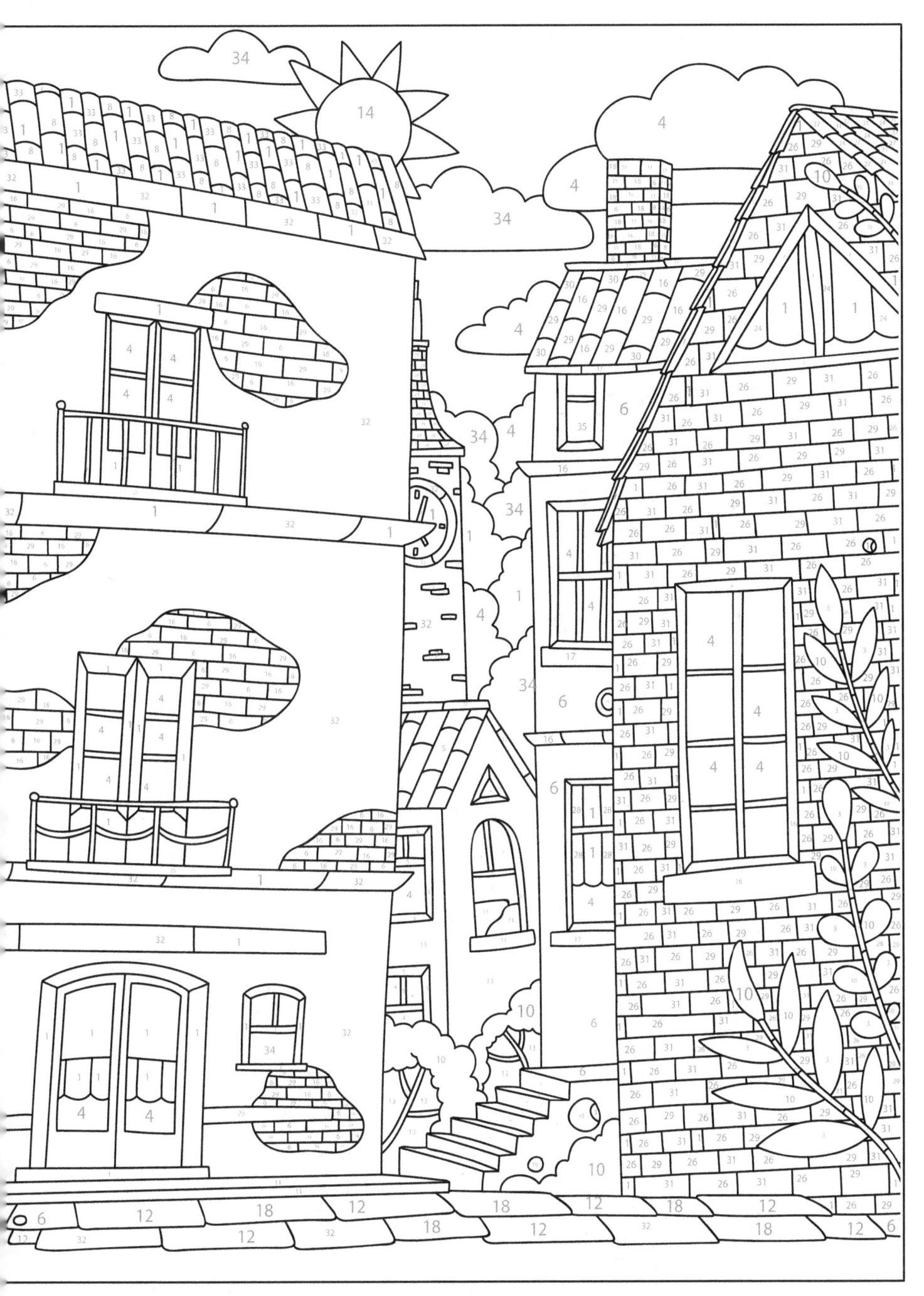

1. Grey
2. Rouge
3. Grass
4. Cadet Blue
5. Island Red
6. Nude
7. Plum
8. Mystery
9. Coral
10. Stem
11. Cocoa
12. Milk Chocolate
13. Mocha
14. Light Yellow
15. Orange
16. Maroon
17. Penny
18. Sand
19. Honey
20. Olive
21. Fern
22. Dark Green
23. Fuchsia
24. Purple
25. Ballet Slipper
26. Rose
27. Punch
28. Sea Green
29. Rosewood
30. Periwinkle
31. Sedona
32. Bone
33. Aegean
34. Baby Blue
35. Dark Yellow

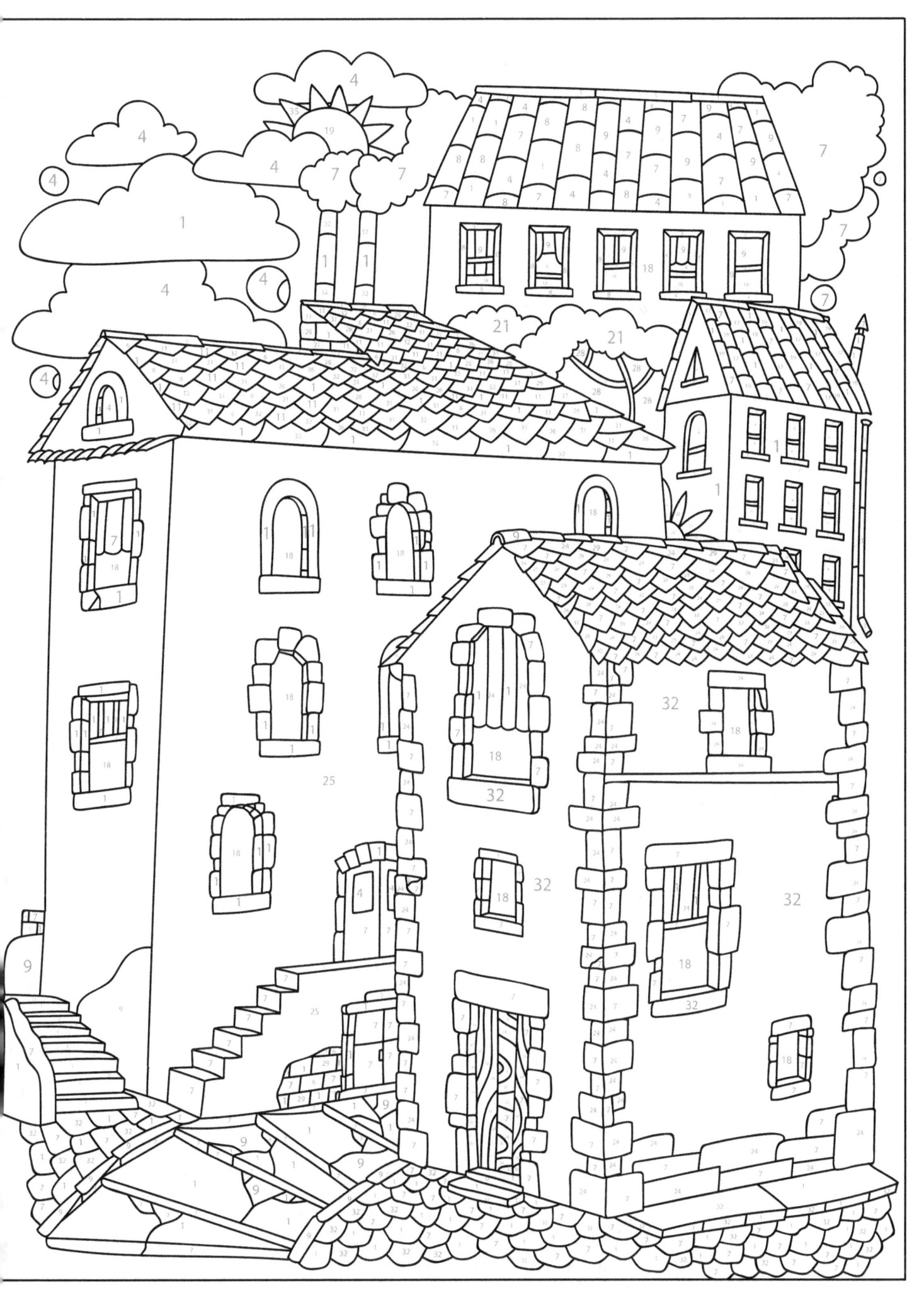

1. Grey
2. Rouge
3. Grass
4. Cadet Blue
5. Island Red
6. Nude
7. Plum
8. Mystery
9. Coral
10. Stem
11. Cocoa
12. Milk Chocolate
13. Mocha
14. Light Yellow
15. Orange
16. Maroon
17. Penny
18. Sand
19. Honey
20. Olive
21. Fern
22. Dark Green
23. Fuchsia
24. Purple
25. Ballet Slipper
26. Rose
27. Punch
28. Sea Green
29. Rosewood
30. Periwinkle
31. Sedona
32. Bone
33. Aegean
34. Baby Blue
35. Dark Yellow

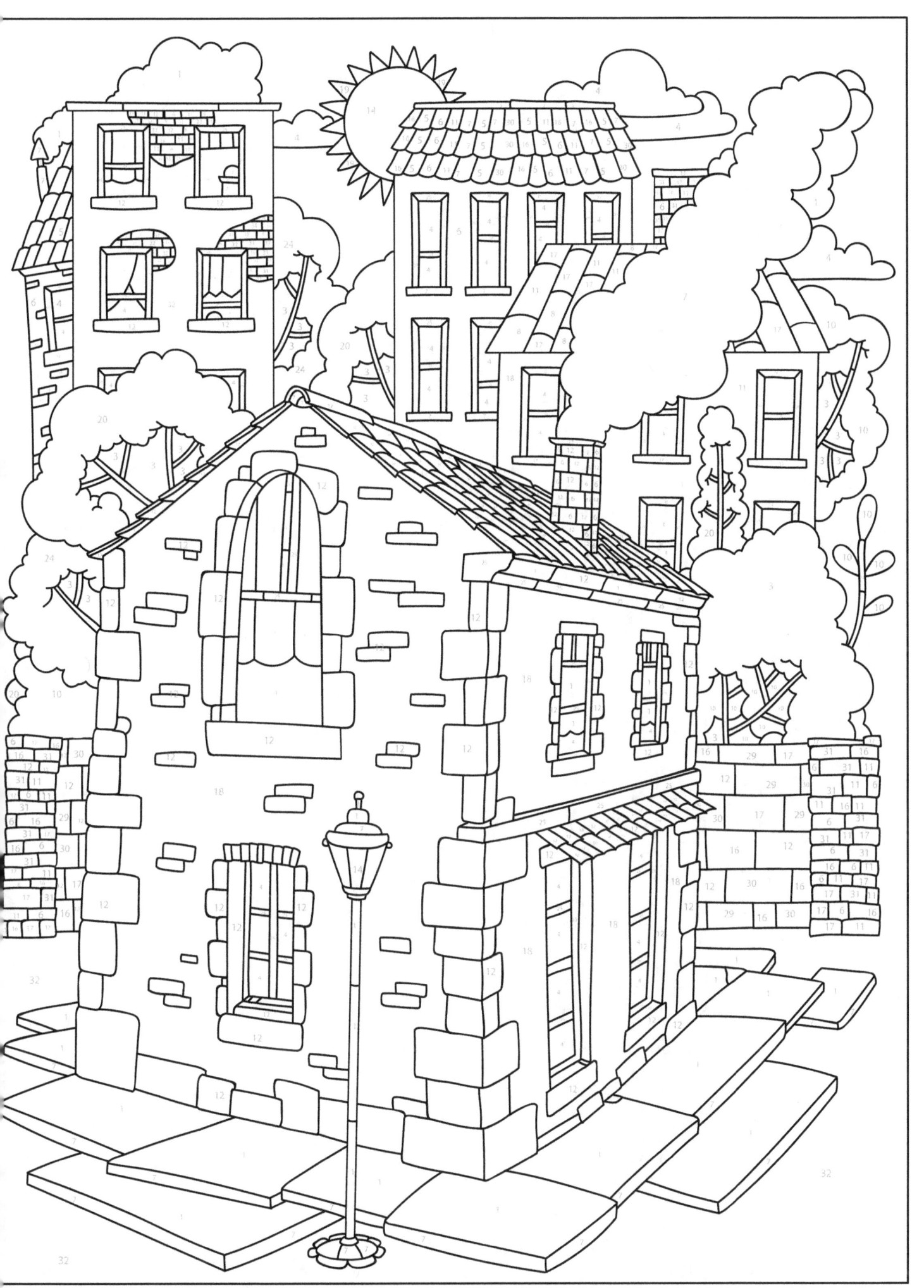

1. Grey
2. Rouge
3. Grass
4. Cadet Blue
5. Island Red
6. Nude
7. Plum
8. Mystery
9. Coral
10. Stem
11. Cocoa
12. Milk Chocolate
13. Mocha
14. Light Yellow
15. Orange
16. Maroon
17. Penny
18. Sand
19. Honey
20. Olive
21. Fern
22. Dark Green
23. Fuchsia
24. Purple
25. Ballet Slipper
26. Rose
27. Punch
28. Sea Green
29. Rosewood
30. Periwinkle
31. Sedona
32. Bone
33. Aegean
34. Baby Blue
35. Dark Yellow

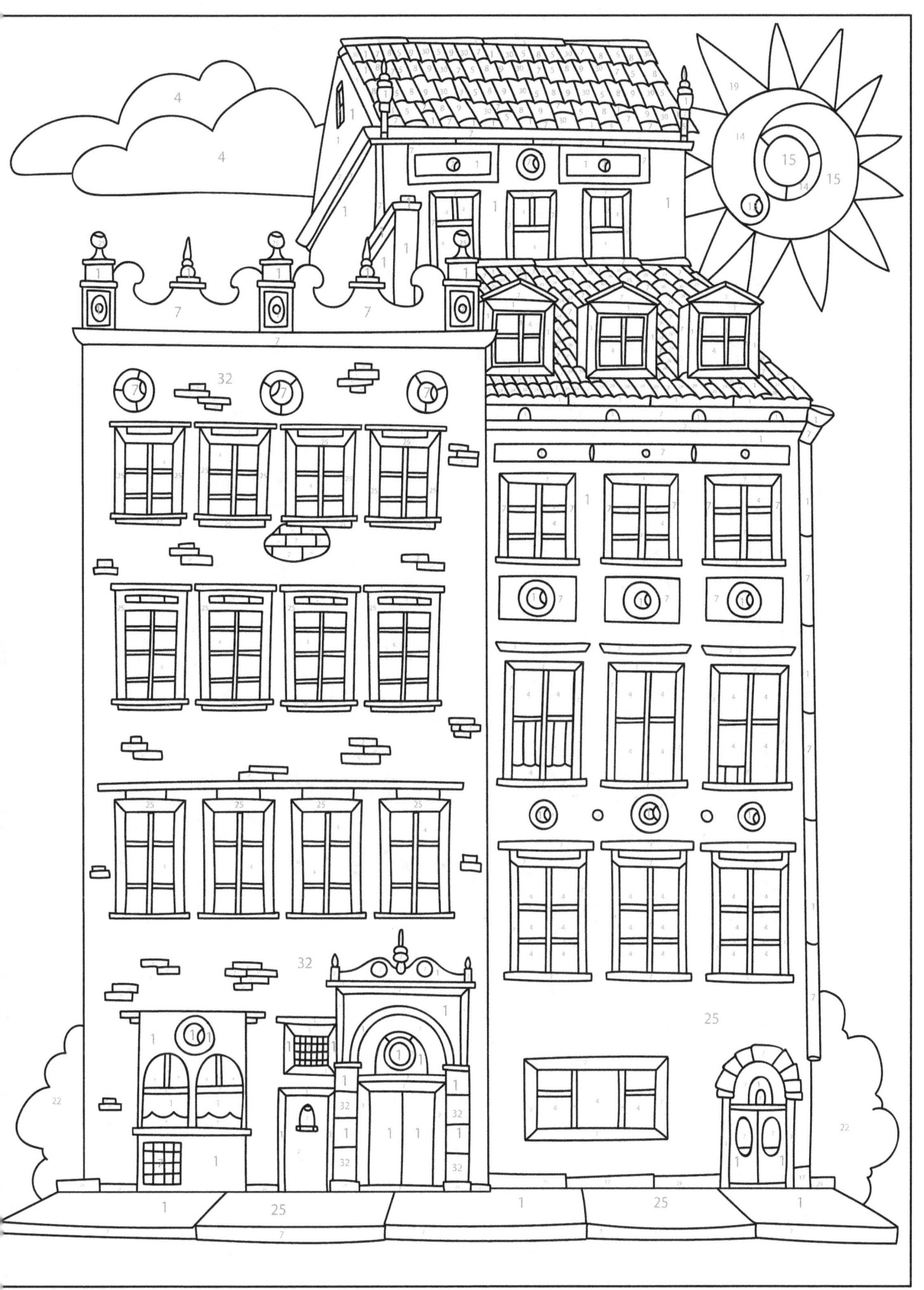

1. Grey
2. Rouge
3. Grass
4. Cadet Blue
5. Island Red
6. Nude
7. Plum
8. Mystery
9. Coral
10. Stem
11. Cocoa
12. Milk Chocolate
13. Mocha
14. Light Yellow
15. Orange
16. Maroon
17. Penny
18. Sand
19. Honey
20. Olive
21. Fern
22. Dark Green
23. Fuchsia
24. Purple
25. Ballet Slipper
26. Rose
27. Punch
28. Sea Green
29. Rosewood
30. Periwinkle
31. Sedona
32. Bone
33. Aegean
34. Baby Blue
35. Dark Yellow

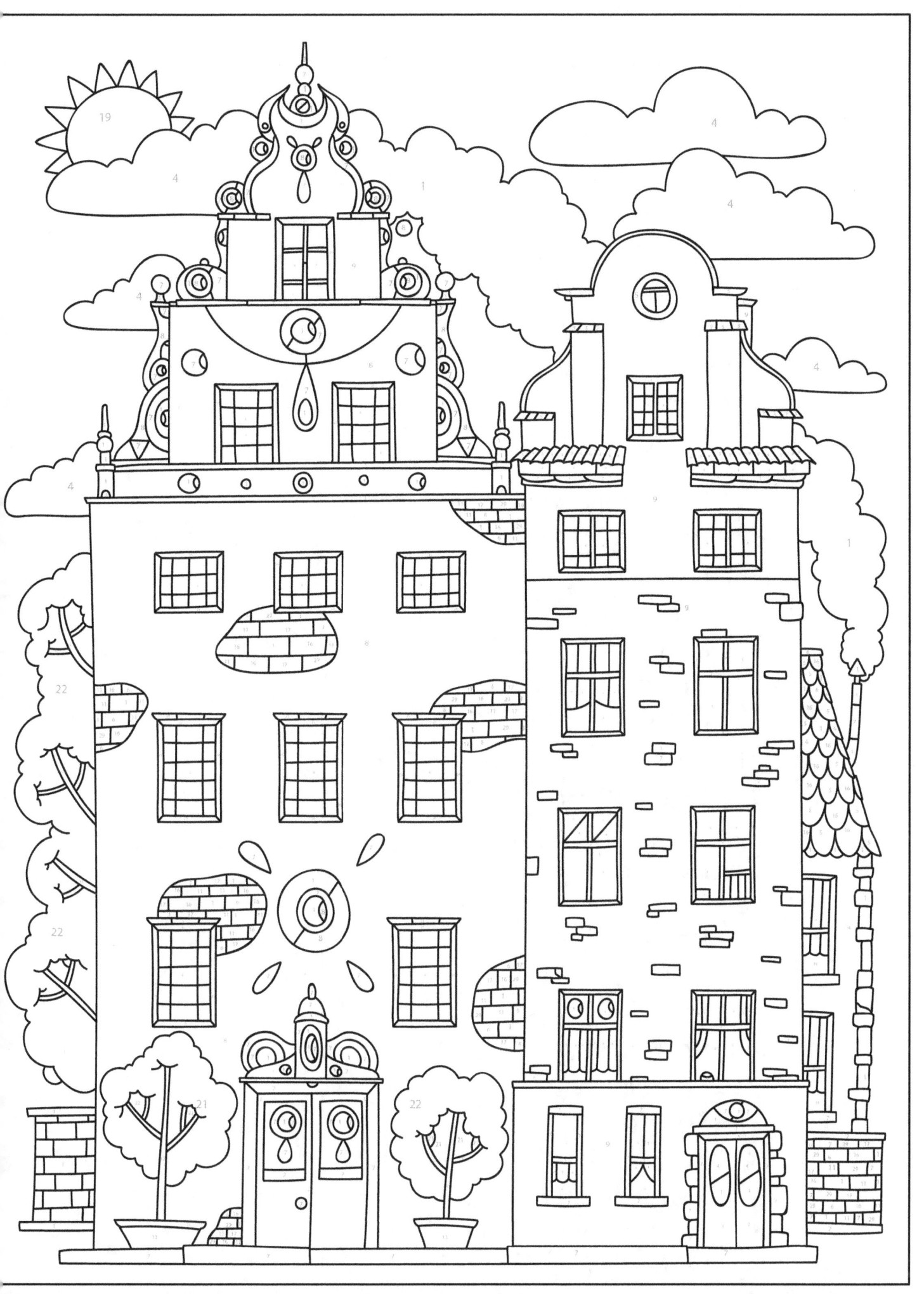

1. Grey
2. Rouge
3. Grass
4. Cadet Blue
5. Island Red
6. Nude
7. Plum
8. Mystery
9. Coral
10. Stem
11. Cocoa
12. Milk Chocolate
13. Mocha
14. Light Yellow
15. Orange
16. Maroon
17. Penny
18. Sand
19. Honey
20. Olive
21. Fern
22. Dark Green
23. Fuchsia
24. Purple
25. Ballet Slipper
26. Rose
27. Punch
28. Sea Green
29. Rosewood
30. Periwinkle
31. Sedona
32. Bone
33. Aegean
34. Baby Blue
35. Dark Yellow

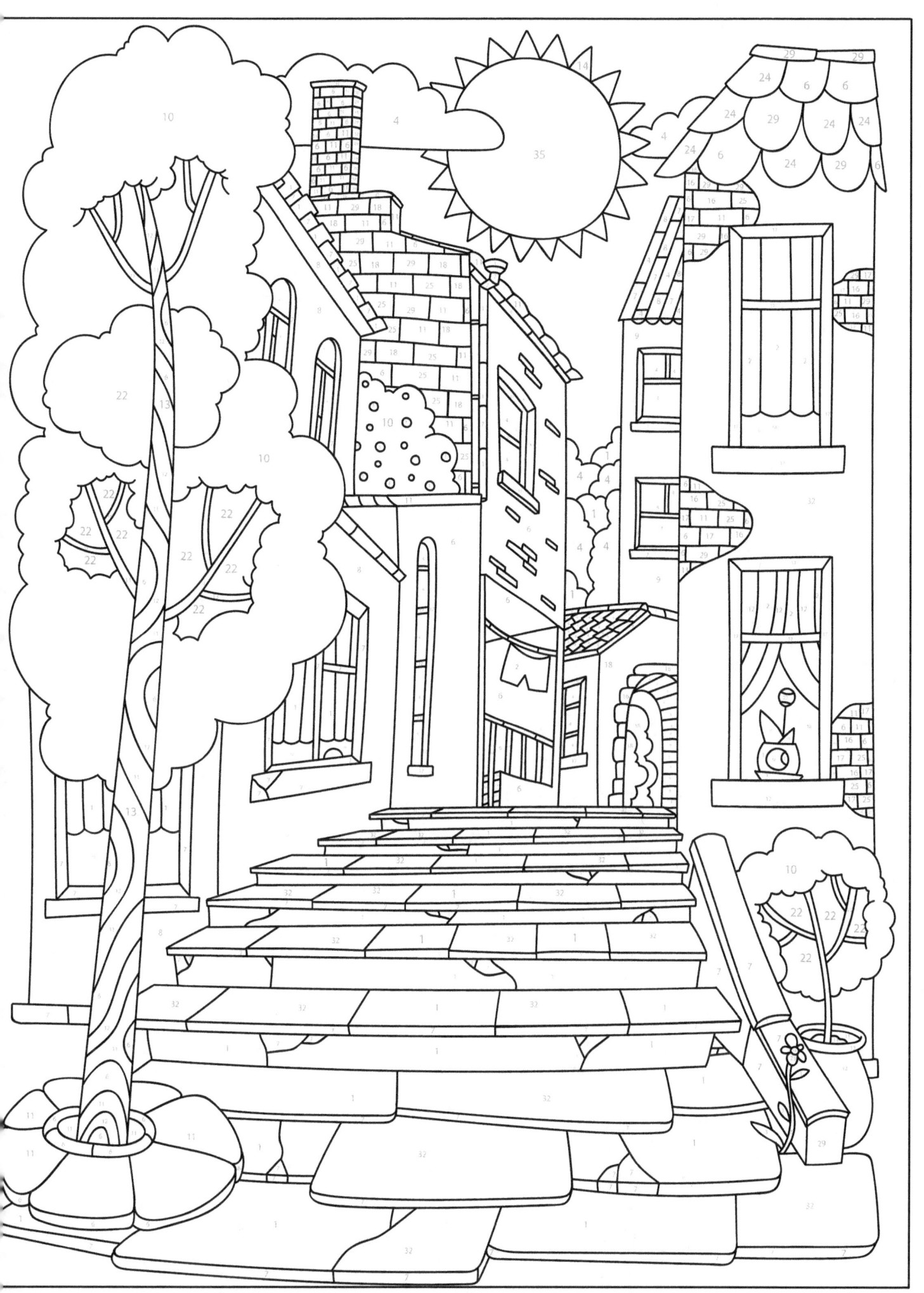

1. Grey
2. Rouge
3. Grass
4. Cadet Blue
5. Island Red
6. Nude
7. Plum
8. Mystery
9. Coral
10. Stem
11. Cocoa
12. Milk Chocolate
13. Mocha
14. Light Yellow
15. Orange
16. Maroon
17. Penny
18. Sand
19. Honey
20. Olive
21. Fern
22. Dark Green
23. Fuchsia
24. Purple
25. Ballet Slipper
26. Rose
27. Punch
28. Sea Green
29. Rosewood
30. Periwinkle
31. Sedona
32. Bone
33. Aegean
34. Baby Blue
35. Dark Yellow

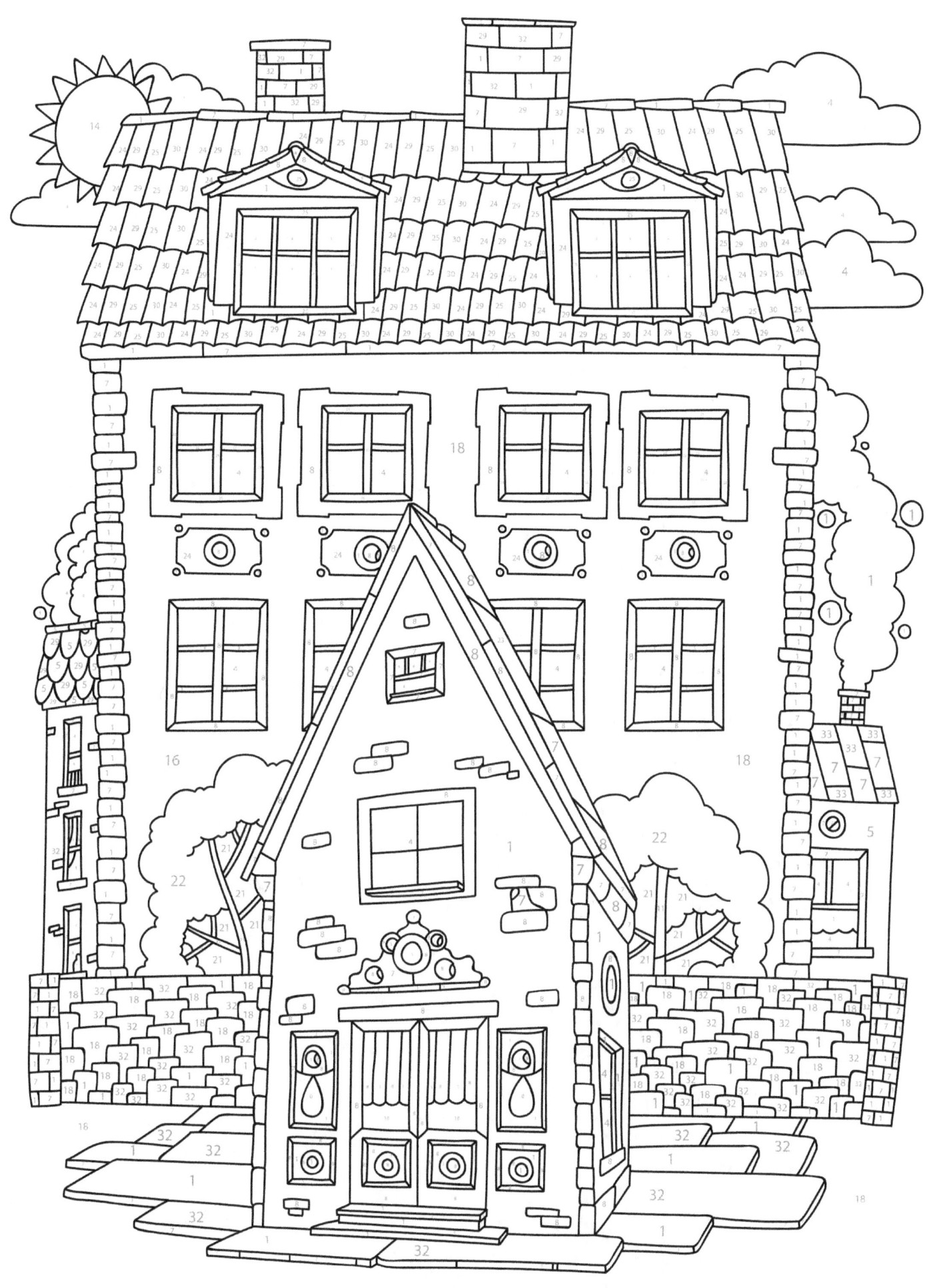

1. Grey
2. Rouge
3. Grass
4. Cadet Blue
5. Island Red
6. Nude
7. Plum
8. Mystery
9. Coral
10. Stem
11. Cocoa
12. Milk Chocolate
13. Mocha
14. Light Yellow
15. Orange
16. Maroon
17. Penny
18. Sand
19. Honey
20. Olive
21. Fern
22. Dark Green
23. Fuchsia
24. Purple
25. Ballet Slipper
26. Rose
27. Punch
28. Sea Green
29. Rosewood
30. Periwinkle
31. Sedona
32. Bone
33. Aegean
34. Baby Blue
35. Dark Yellow

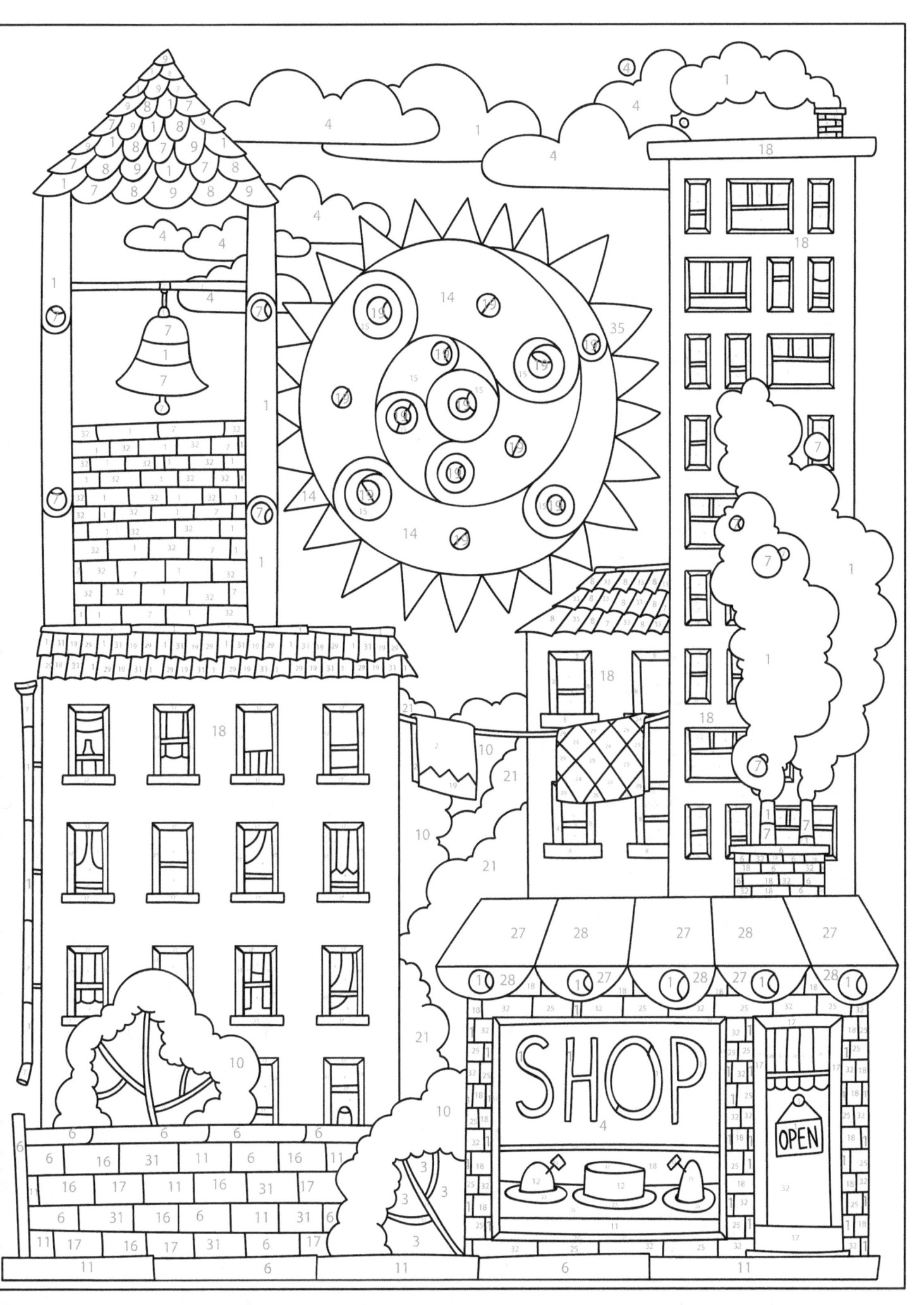

1. Grey
2. Rouge
3. Grass
4. Cadet Blue
5. Island Red
6. Nude
7. Plum
8. Mystery
9. Coral
10. Stem
11. Cocoa
12. Milk Chocolate
13. Mocha
14. Light Yellow
15. Orange
16. Maroon
17. Penny
18. Sand
19. Honey
20. Olive
21. Fern
22. Dark Green
23. Fuchsia
24. Purple
25. Ballet Slipper
26. Rose
27. Punch
28. Sea Green
29. Rosewood
30. Periwinkle
31. Sedona
32. Bone
33. Aegean
34. Baby Blue
35. Dark Yellow

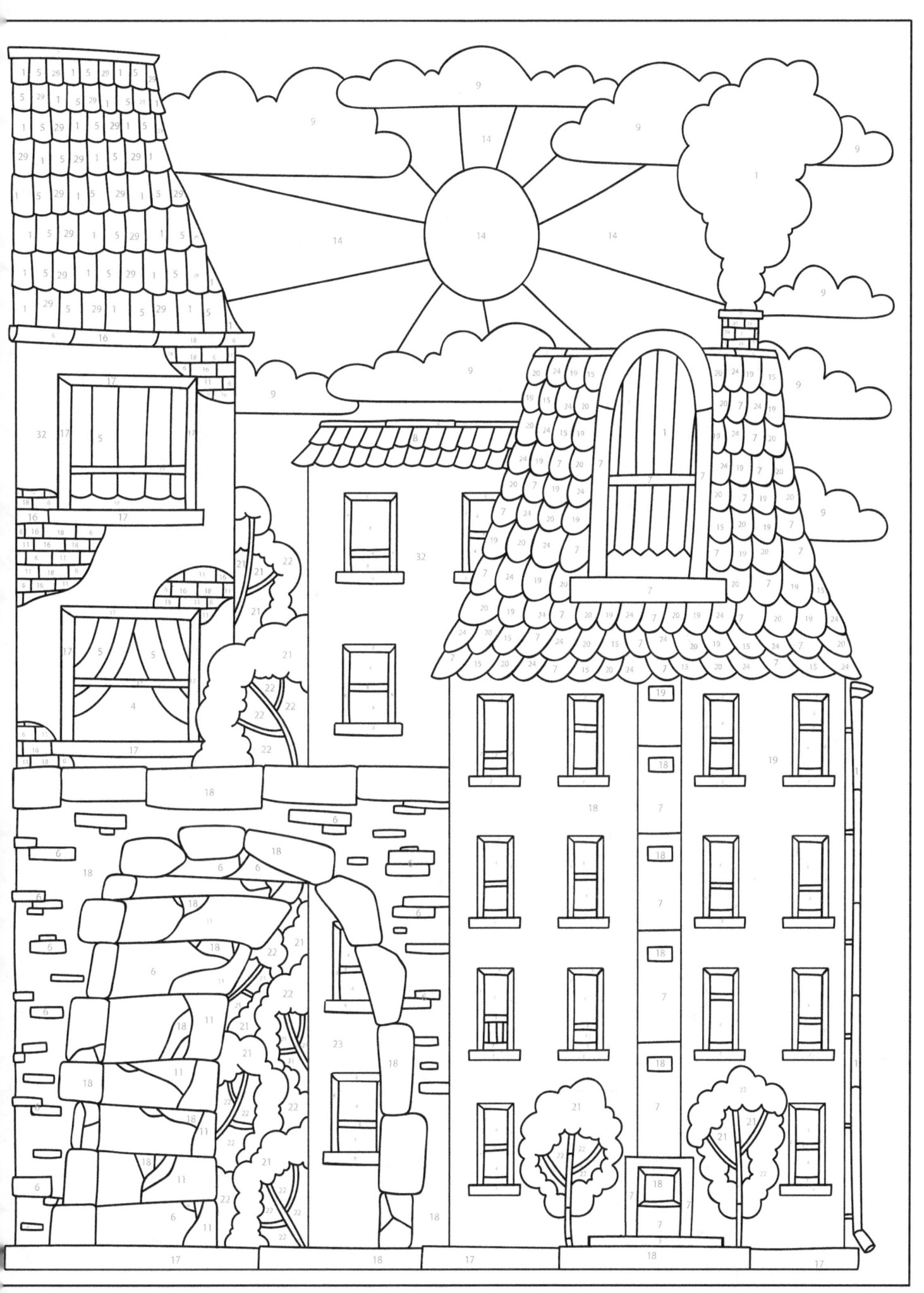

1. Grey
2. Rouge
3. Grass
4. Cadet Blue
5. Island Red
6. Nude
7. Plum
8. Mystery
9. Coral
10. Stem
11. Cocoa
12. Milk Chocolate
13. Mocha
14. Light Yellow
15. Orange
16. Maroon
17. Penny
18. Sand
19. Honey
20. Olive
21. Fern
22. Dark Green
23. Fuchsia
24. Purple
25. Ballet Slipper
26. Rose
27. Punch
28. Sea Green
29. Rosewood
30. Periwinkle
31. Sedona
32. Bone
33. Aegean
34. Baby Blue
35. Dark Yellow

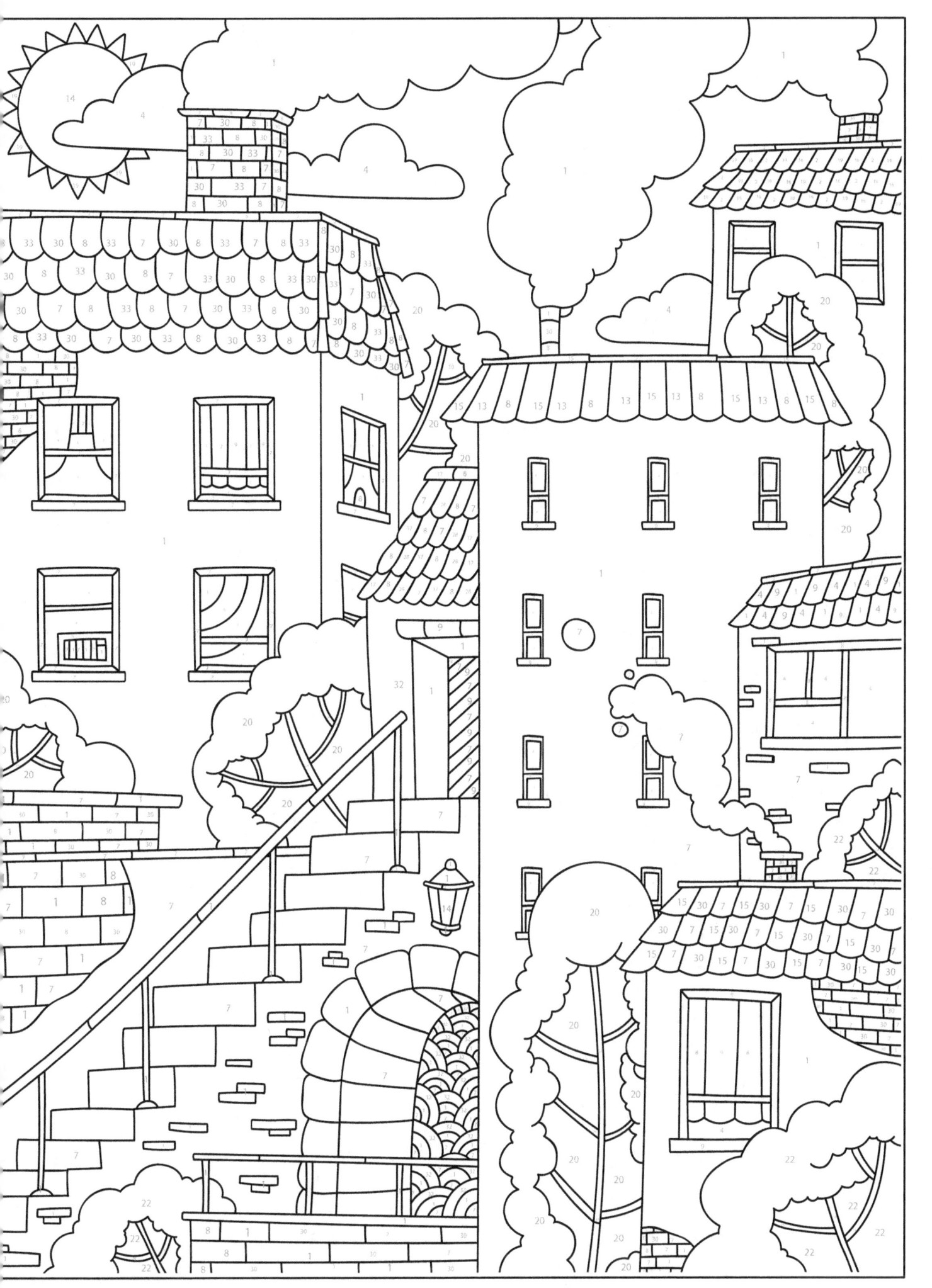

1. Grey
2. Rouge
3. Grass
4. Cadet Blue
5. Island Red
6. Nude
7. Plum
8. Mystery
9. Coral
10. Stem
11. Cocoa
12. Milk Chocolate
13. Mocha
14. Light Yellow
15. Orange
16. Maroon
17. Penny
18. Sand
19. Honey
20. Olive
21. Fern
22. Dark Green
23. Fuchsia
24. Purple
25. Ballet Slipper
26. Rose
27. Punch
28. Sea Green
29. Rosewood
30. Periwinkle
31. Sedona
32. Bone
33. Aegean
34. Baby Blue
35. Dark Yellow

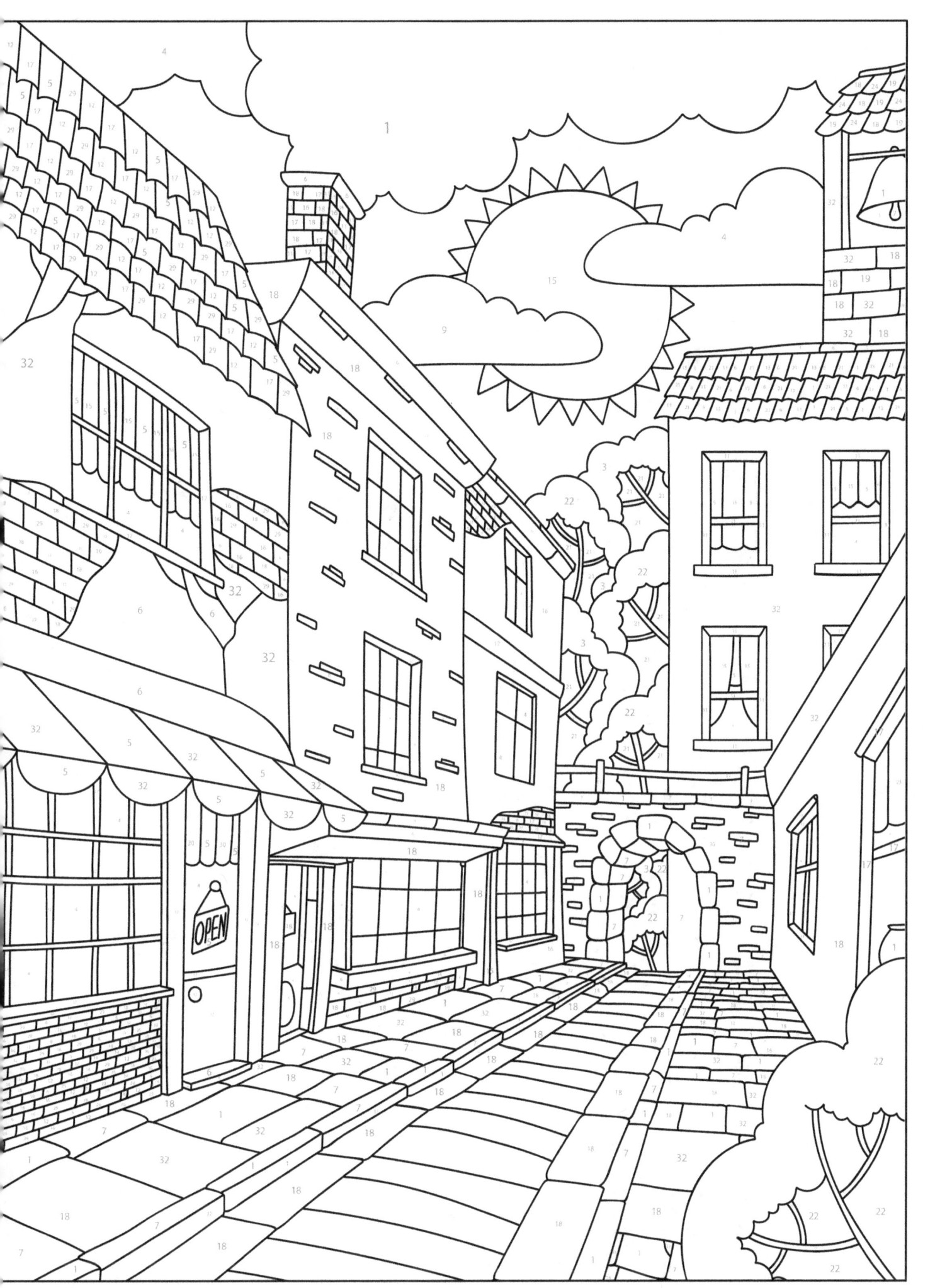

1. Grey
2. Rouge
3. Grass
4. Cadet Blue
5. Island Red
6. Nude
7. Plum
8. Mystery
9. Coral
10. Stem
11. Cocoa
12. Milk Chocolate
13. Mocha
14. Light Yellow
15. Orange
16. Maroon
17. Penny
18. Sand
19. Honey
20. Olive
21. Fern
22. Dark Green
23. Fuchsia
24. Purple
25. Ballet Slipper
26. Rose
27. Punch
28. Sea Green
29. Rosewood
30. Periwinkle
31. Sedona
32. Bone
33. Aegean
34. Baby Blue
35. Dark Yellow

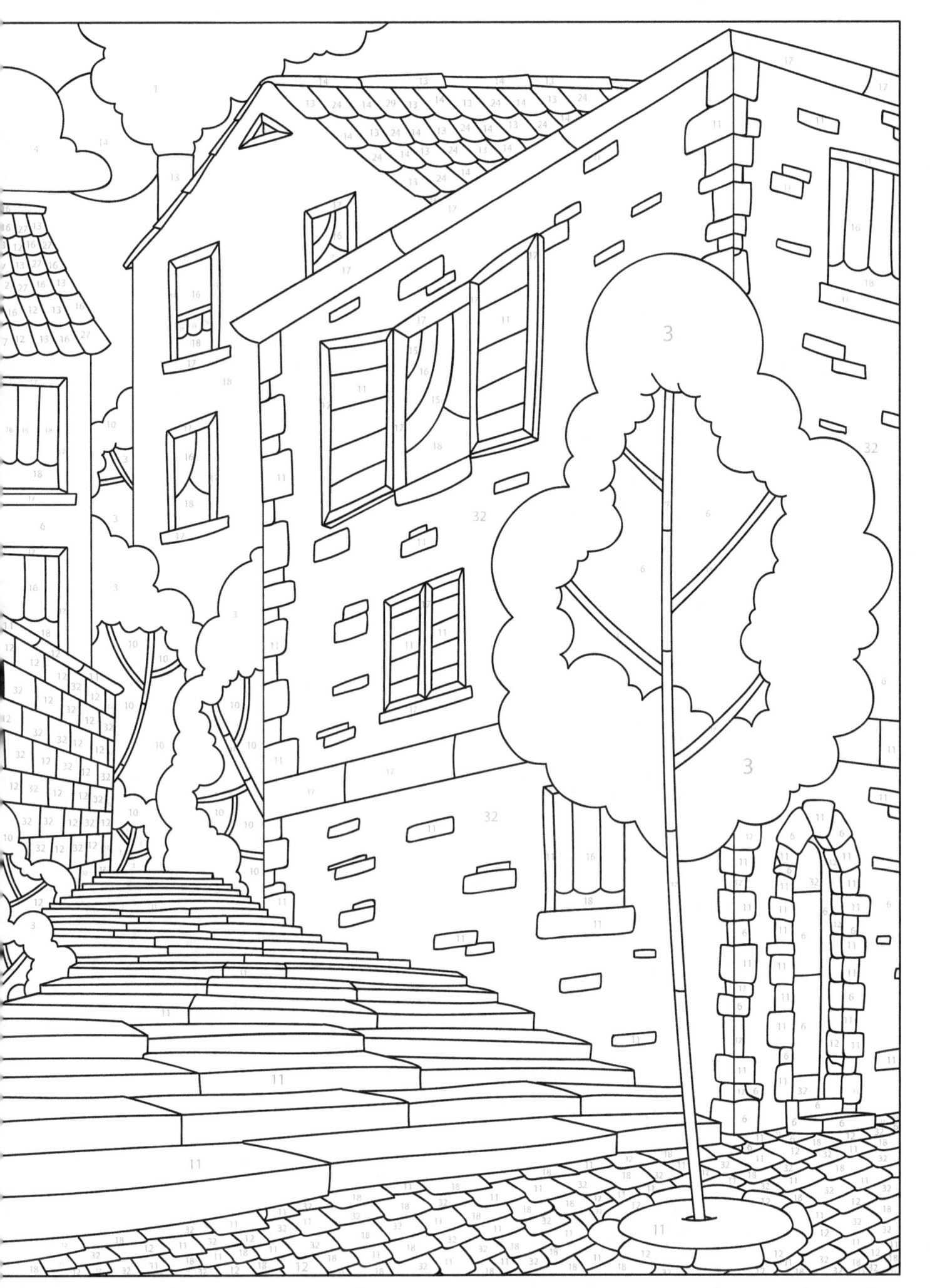

1. Grey
2. Rouge
3. Grass
4. Cadet Blue
5. Island Red
6. Nude
7. Plum
8. Mystery
9. Coral
10. Stem
11. Cocoa
12. Milk Chocolate
13. Mocha
14. Light Yellow
15. Orange
16. Maroon
17. Penny
18. Sand
19. Honey
20. Olive
21. Fern
22. Dark Green
23. Fuchsia
24. Purple
25. Ballet Slipper
26. Rose
27. Punch
28. Sea Green
29. Rosewood
30. Periwinkle
31. Sedona
32. Bone
33. Aegean
34. Baby Blue
35. Dark Yellow

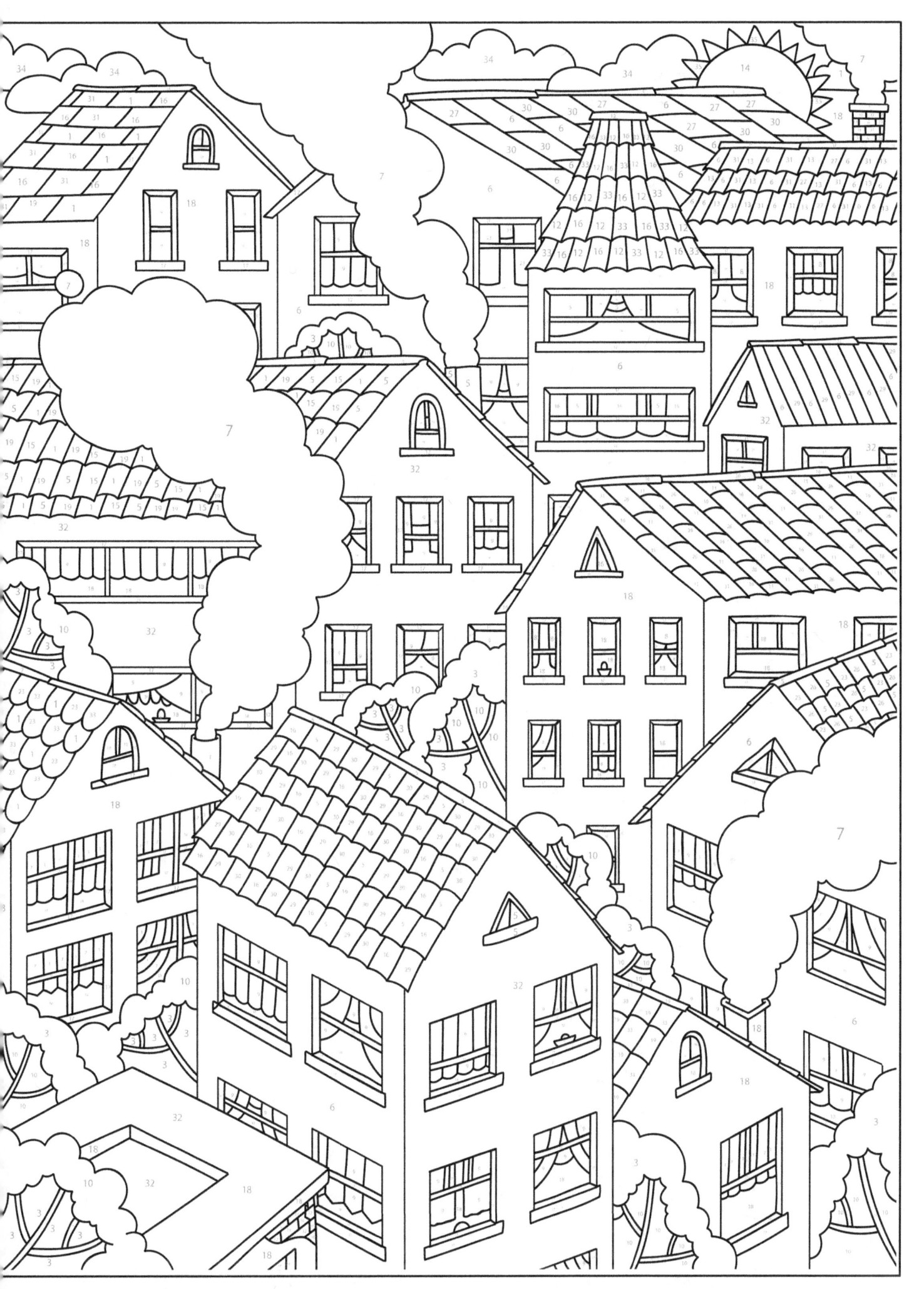

1. Grey
2. Rouge
3. Grass
4. Cadet Blue
5. Island Red
6. Nude
7. Plum
8. Mystery
9. Coral
10. Stem
11. Cocoa
12. Milk Chocolate
13. Mocha
14. Light Yellow
15. Orange
16. Maroon
17. Penny
18. Sand
19. Honey
20. Olive
21. Fern
22. Dark Green
23. Fuchsia
24. Purple
25. Ballet Slipper
26. Rose
27. Punch
28. Sea Green
29. Rosewood
30. Periwinkle
31. Sedona
32. Bone
33. Aegean
34. Baby Blue
35. Dark Yellow

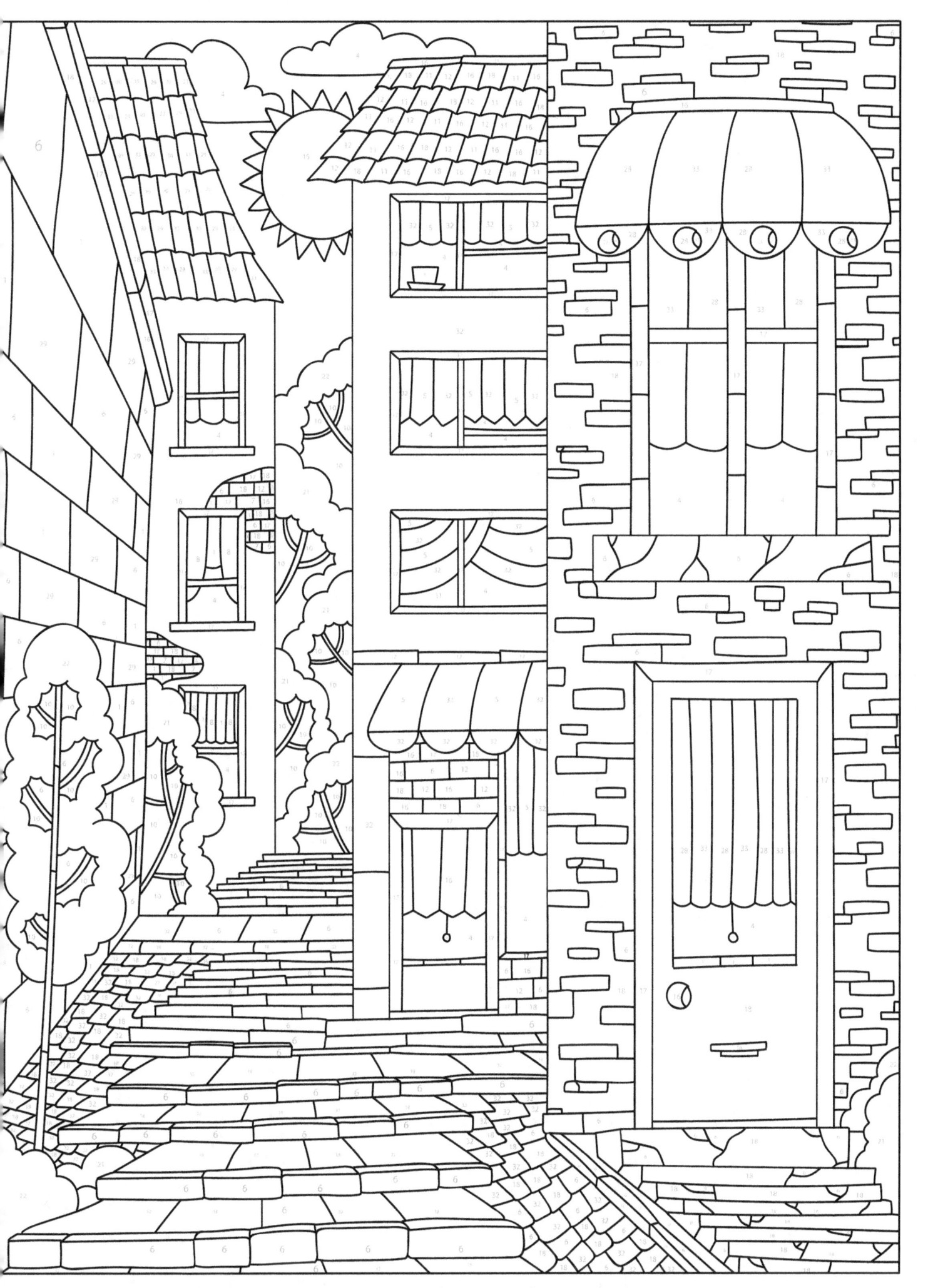

1. Grey
2. Rouge
3. Grass
4. Cadet Blue
5. Island Red
6. Nude
7. Plum
8. Mystery
9. Coral
10. Stem
11. Cocoa
12. Milk Chocolate
13. Mocha
14. Light Yellow
15. Orange
16. Maroon
17. Penny
18. Sand
19. Honey
20. Olive
21. Fern
22. Dark Green
23. Fuchsia
24. Purple
25. Ballet Slipper
26. Rose
27. Punch
28. Sea Green
29. Rosewood
30. Periwinkle
31. Sedona
32. Bone
33. Aegean
34. Baby Blue
35. Dark Yellow

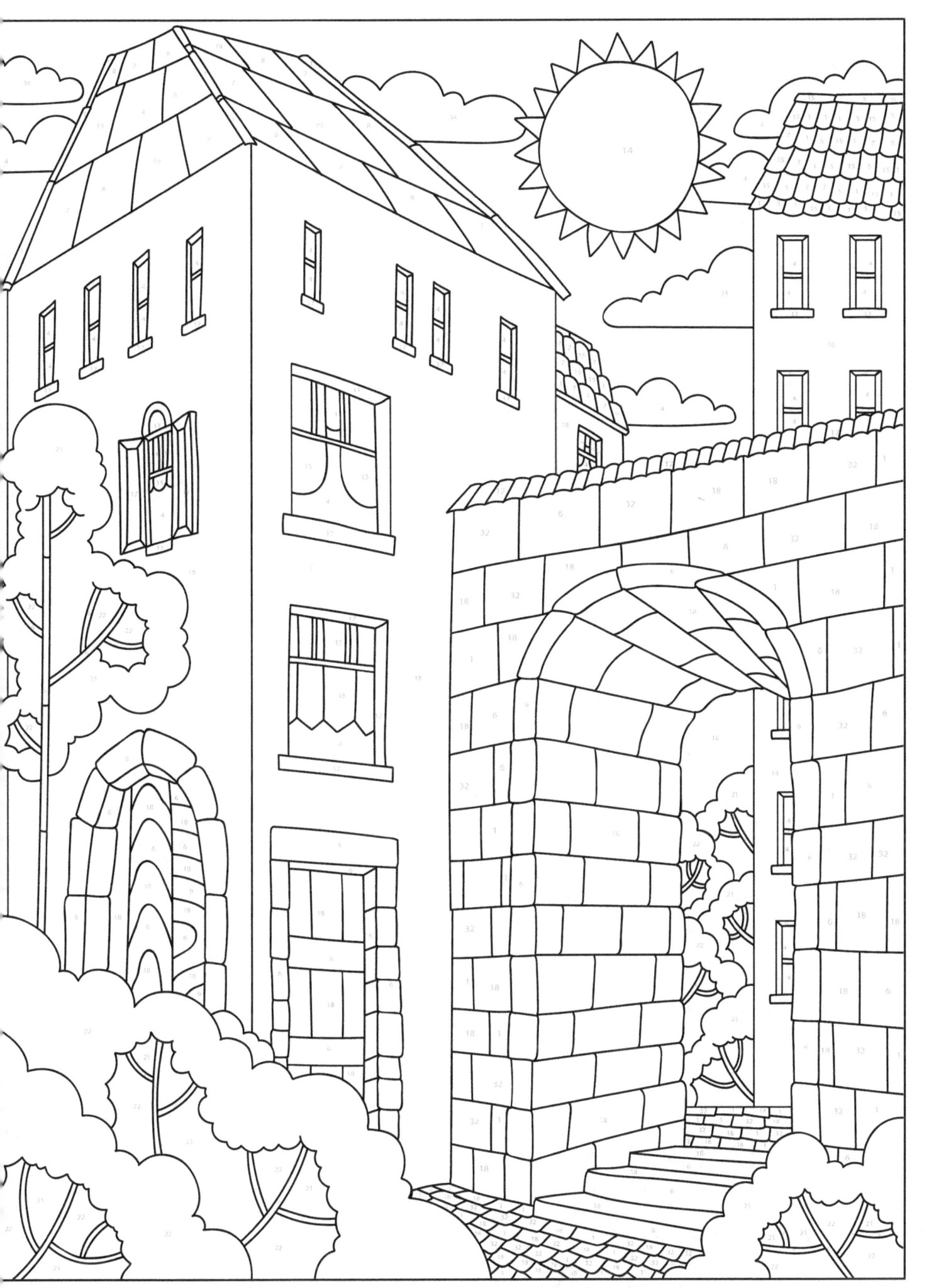

1. Grey
2. Rouge
3. Grass
4. Cadet Blue
5. Island Red
6. Nude
7. Plum
8. Mystery
9. Coral
10. Stem
11. Cocoa
12. Milk Chocolate
13. Mocha
14. Light Yellow
15. Orange
16. Maroon
17. Penny
18. Sand
19. Honey
20. Olive
21. Fern
22. Dark Green
23. Fuchsia
24. Purple
25. Ballet Slipper
26. Rose
27. Punch
28. Sea Green
29. Rosewood
30. Periwinkle
31. Sedona
32. Bone
33. Aegean
34. Baby Blue
35. Dark Yellow

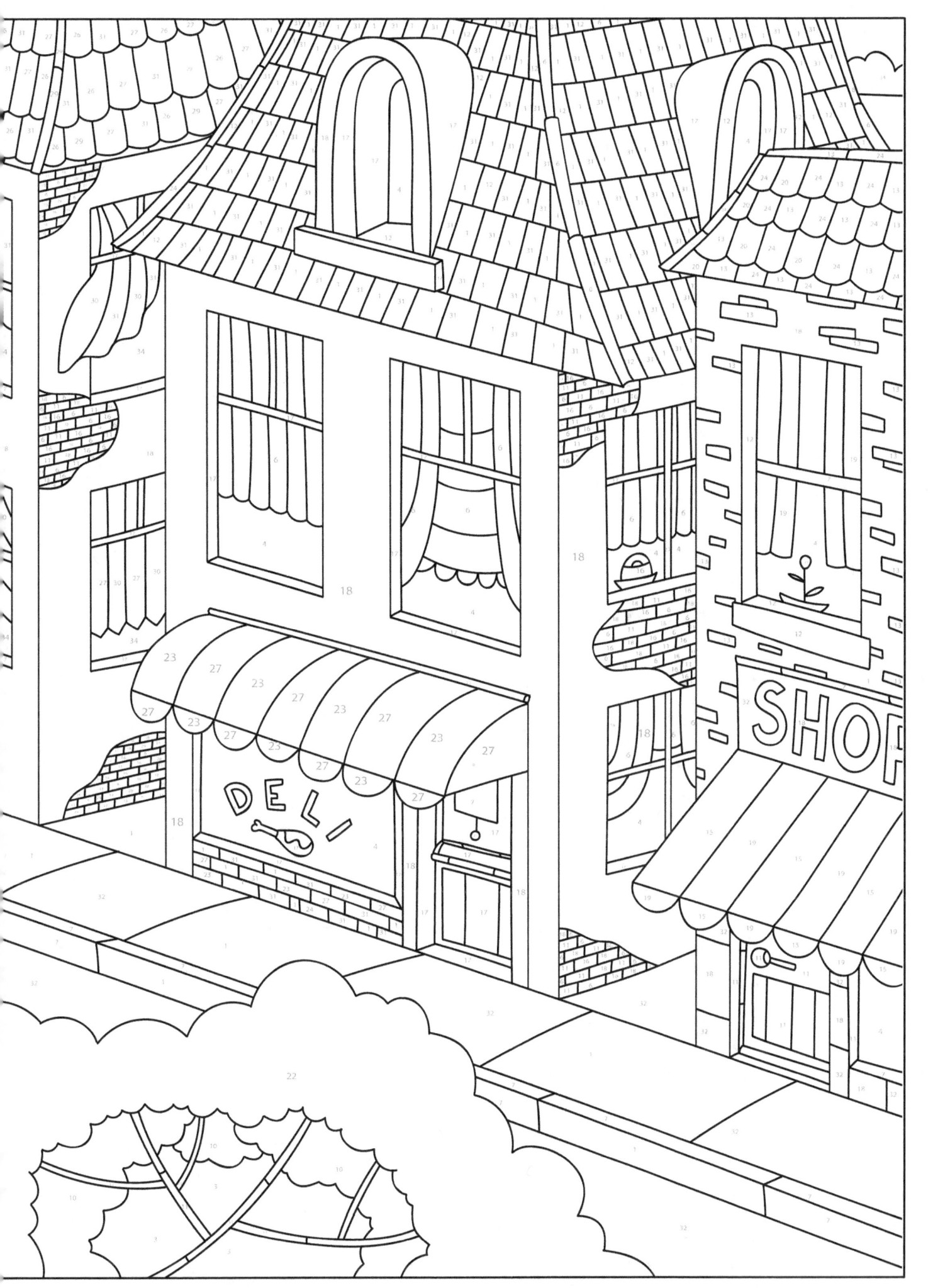

1. Grey
2. Rouge
3. Grass
4. Cadet Blue
5. Island Red
6. Nude
7. Plum
8. Mystery
9. Coral
10. Stem
11. Cocoa
12. Milk Chocolate
13. Mocha
14. Light Yellow
15. Orange
16. Maroon
17. Penny
18. Sand
19. Honey
20. Olive
21. Fern
22. Dark Green
23. Fuchsia
24. Purple
25. Ballet Slipper
26. Rose
27. Punch
28. Sea Green
29. Rosewood
30. Periwinkle
31. Sedona
32. Bone
33. Aegean
34. Baby Blue
35. Dark Yellow

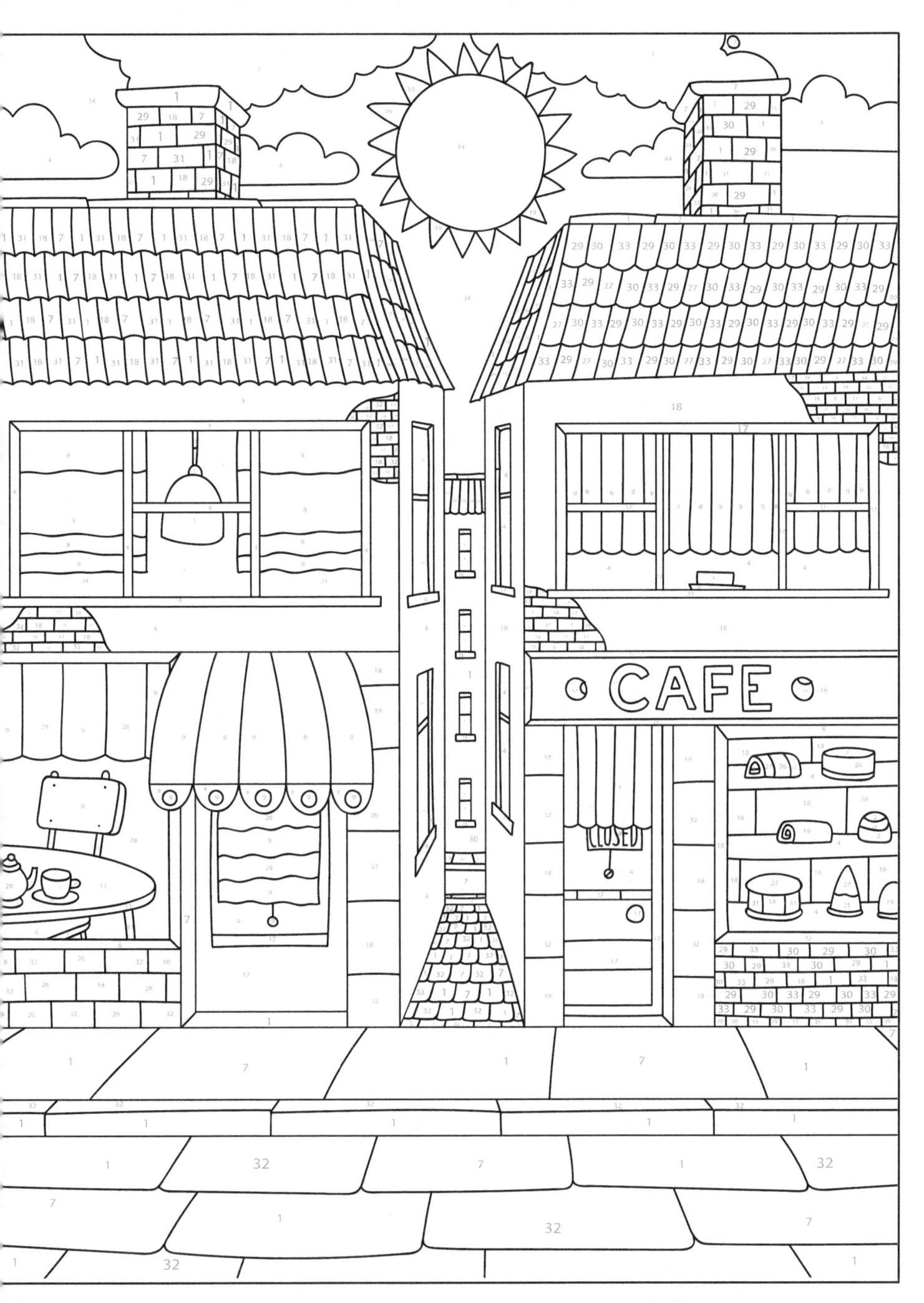

1. Grey
2. Rouge
3. Grass
4. Cadet Blue
5. Island Red
6. Nude
7. Plum
8. Mystery
9. Coral
10. Stem
11. Cocoa
12. Milk Chocolate
13. Mocha
14. Light Yellow
15. Orange
16. Maroon
17. Penny
18. Sand
19. Honey
20. Olive
21. Fern
22. Dark Green
23. Fuchsia
24. Purple
25. Ballet Slipper
26. Rose
27. Punch
28. Sea Green
29. Rosewood
30. Periwinkle
31. Sedona
32. Bone
33. Aegean
34. Baby Blue
35. Dark Yellow

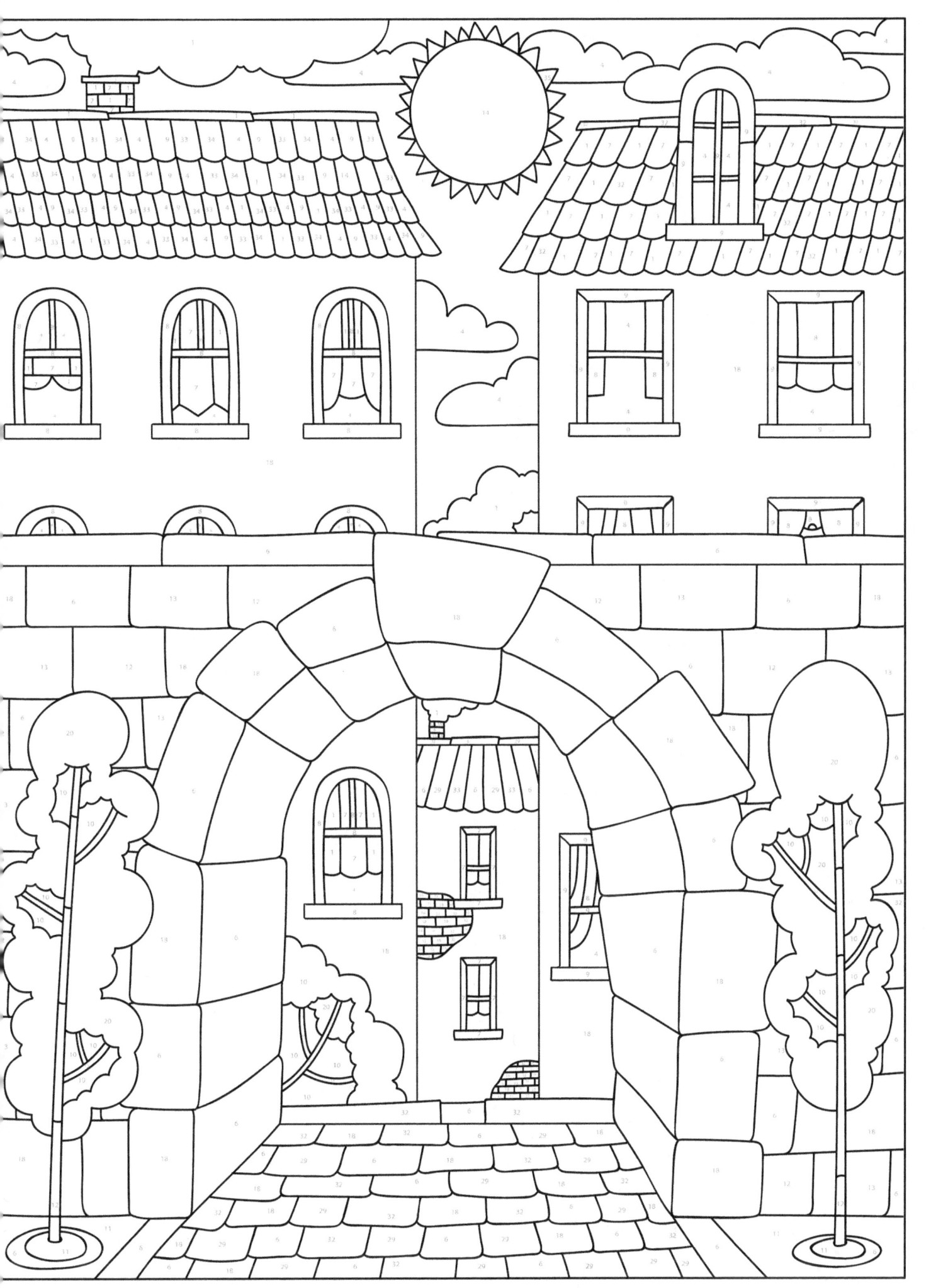

1. Grey
2. Rouge
3. Grass
4. Cadet Blue
5. Island Red
6. Nude
7. Plum
8. Mystery
9. Coral
10. Stem
11. Cocoa
12. Milk Chocolate
13. Mocha
14. Light Yellow
15. Orange
16. Maroon
17. Penny
18. Sand
19. Honey
20. Olive
21. Fern
22. Dark Green
23. Fuchsia
24. Purple
25. Ballet Slipper
26. Rose
27. Punch
28. Sea Green
29. Rosewood
30. Periwinkle
31. Sedona
32. Bone
33. Aegean
34. Baby Blue
35. Dark Yellow

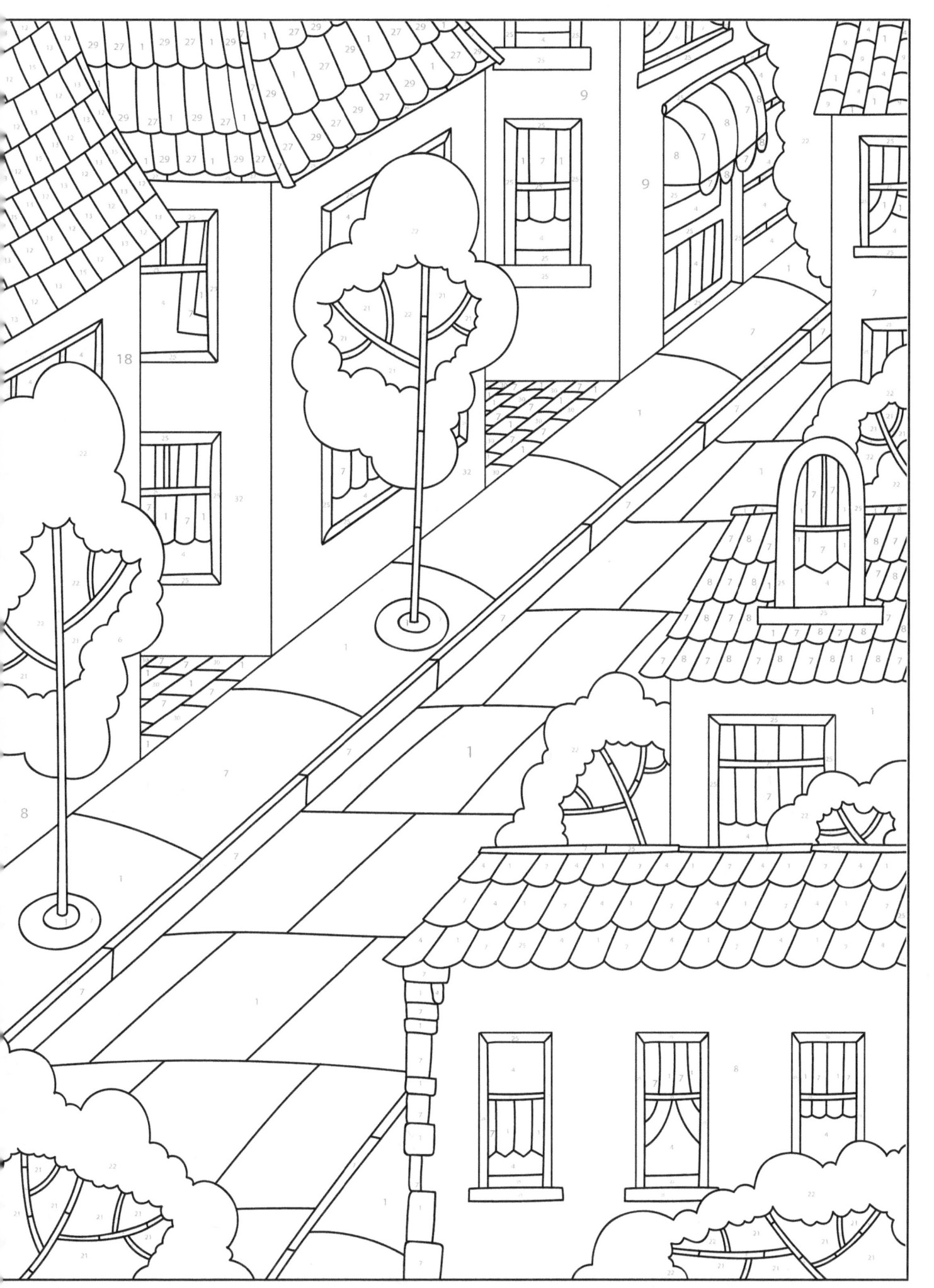

Thank you for supporting
ZenMaster Coloring Books

Your support means the world to us, and we're thrilled to have you embark on this creative journey with us.

Our small company strives to make a BIG difference by helping those who may be less fortunate.

This is why we proudly hire struggling artists from around the world!

Our goal is to provide financial support to artists and their families by enabling them to pursue their passions and share their hard work and limitless talent with you!

Help support our hard working artists by leaving a positive review on Amazon!

And follow us on Facebook for updates and FREE COLORING PAGES!

https://www.facebook.com/zenmastercoloringbooks/

Check out more of our books at:
amazon.com/author/zenmastercoloringbooks

Free Bonus Page!
from:

Extreme dot to dot book of
Butterflies and Flowers

https://amzn.com/dp/1717596746

Also available in color by numbers!!
https://www.amazon.com/dp/1977932398

And a non-numbered edition
https://www.amazon.com/dp/1977882978

Free Bonus Page!
from:

Adult Coloring Book of
Island Dreams Vacation

https://www.amazon.com/dp/1976291267

Also available in color by numbers!!
https://www.amazon.com/dp/1976507707

And 5x8" Travel Size
https://www.amazon.com/dp/1796516090

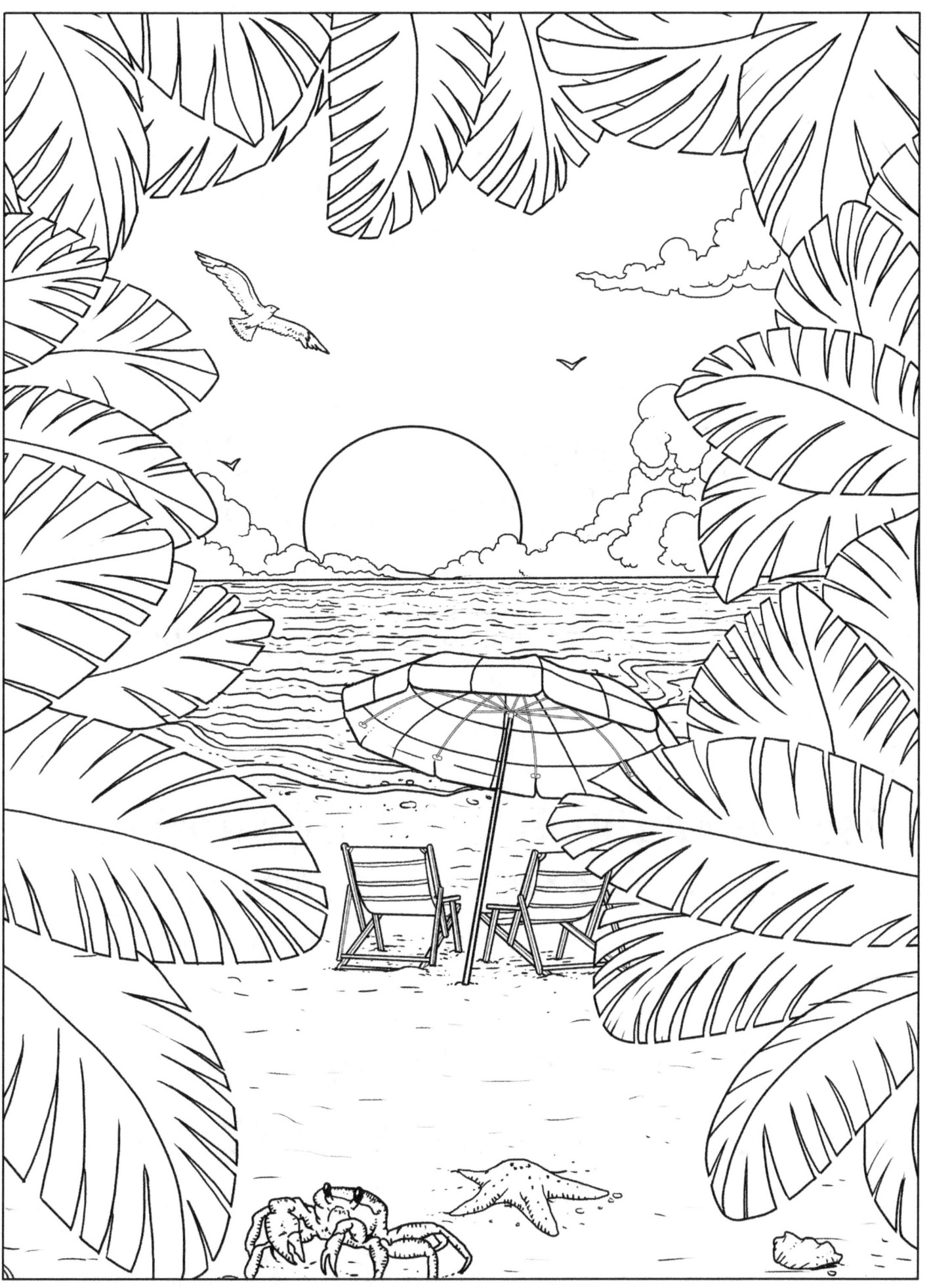

Free Bonus Page!
from:

Kittens and Cats
coloring book for adults

https://www.amazon.com/dp/1977939619

Also available in color by numbers!!
https://www.amazon.com/dp/1979069018

And 5x8" Travel Size
https://www.amazon.com/dp/1727552628

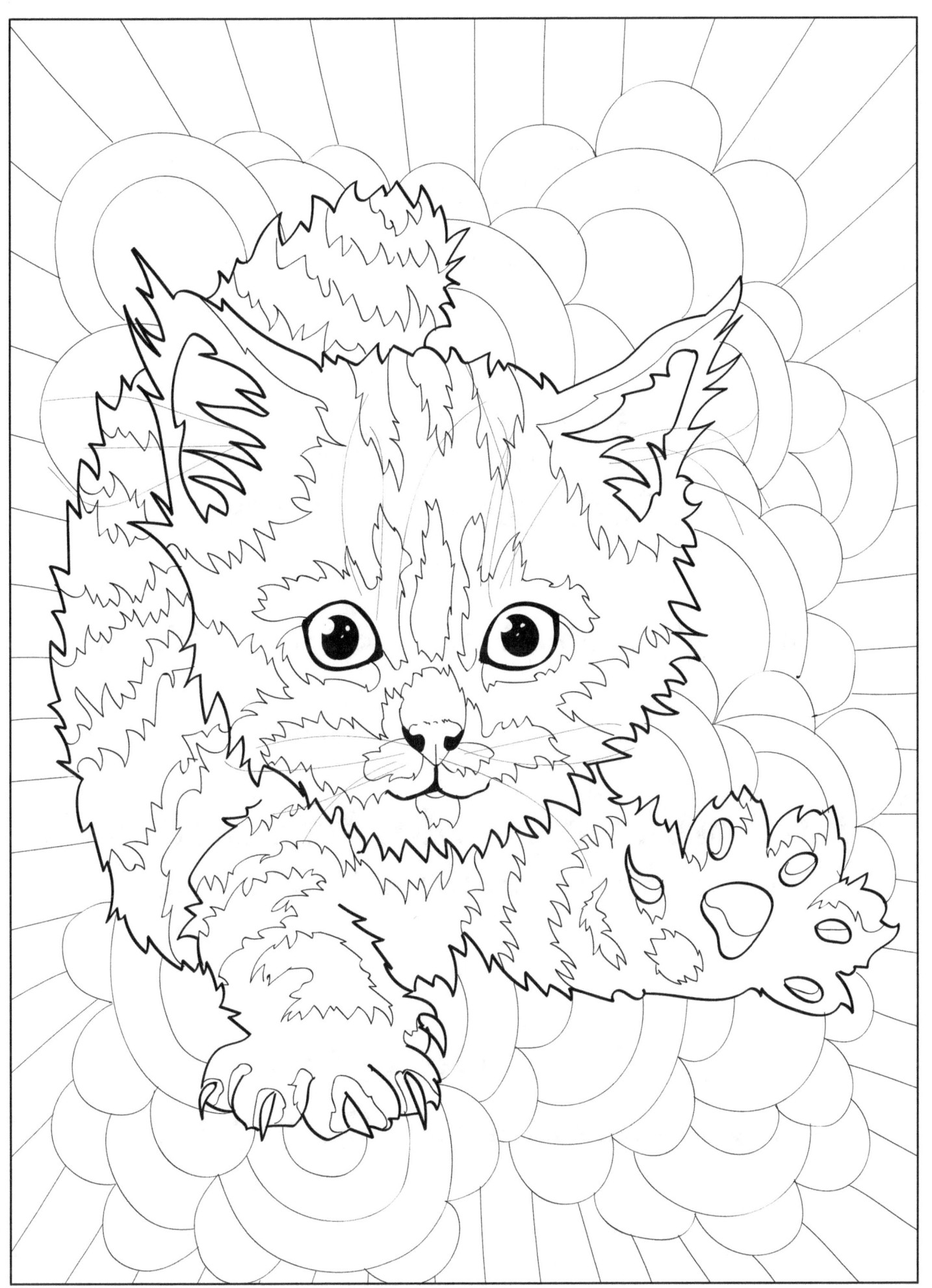

Free Bonus Page!
from:

Koi Fish
coloring book for adults

https://www.amazon.com/dp/1977939619

Also available in color by numbers!!
https://www.amazon.com/dp/198149104x

And 5x8" Travel Size
https://www.amazon.com/dp/1727375149

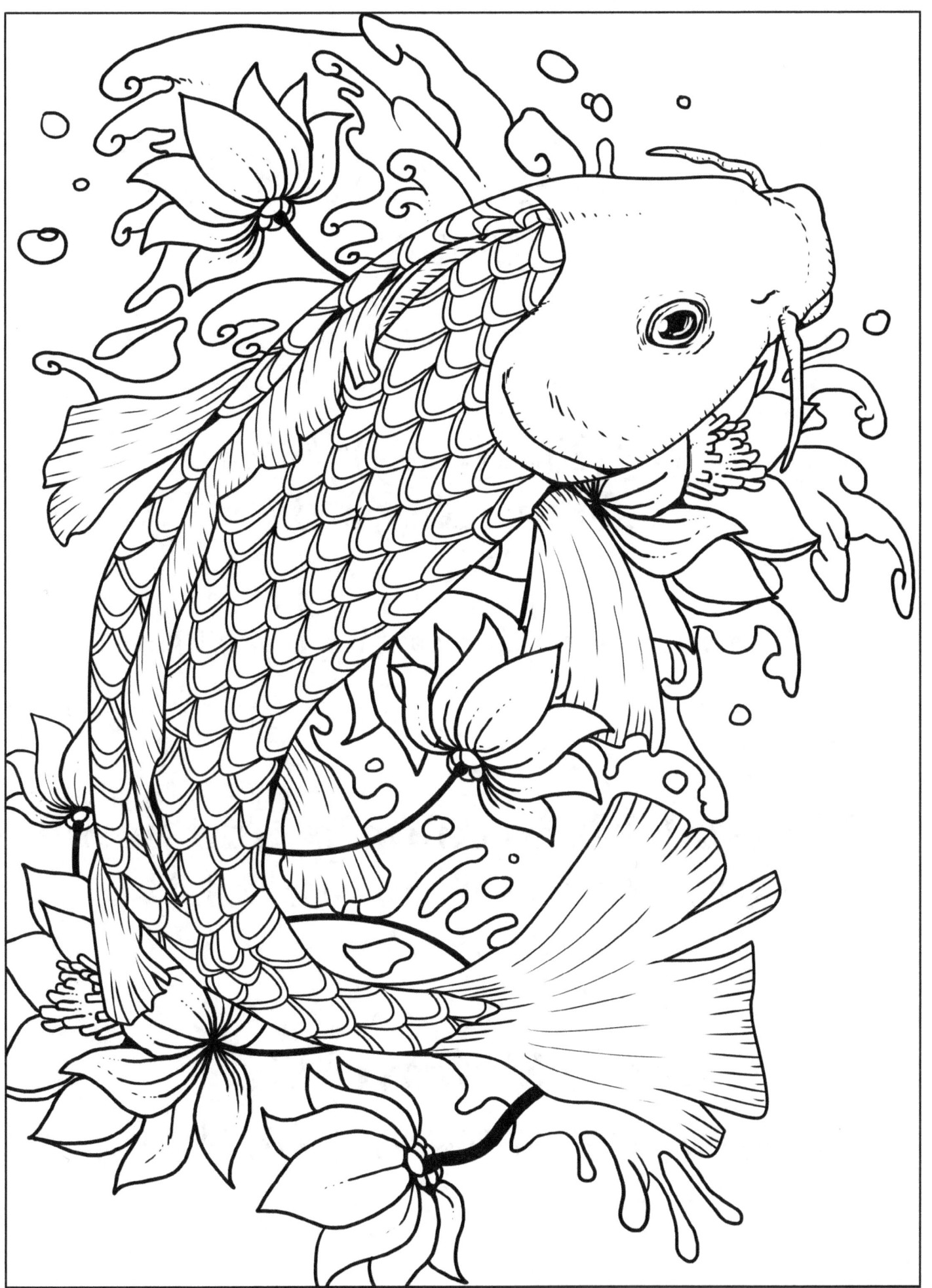

Free Bonus Page!
from:

Vogue 1950s
adult coloring book

https://www.amazon.com/dp/1973981521

Also available in color by numbers!!
https://www.amazon.com/dp/1978343884

And 5x8" Travel Size
https://www.amazon.com/dp/1973981610

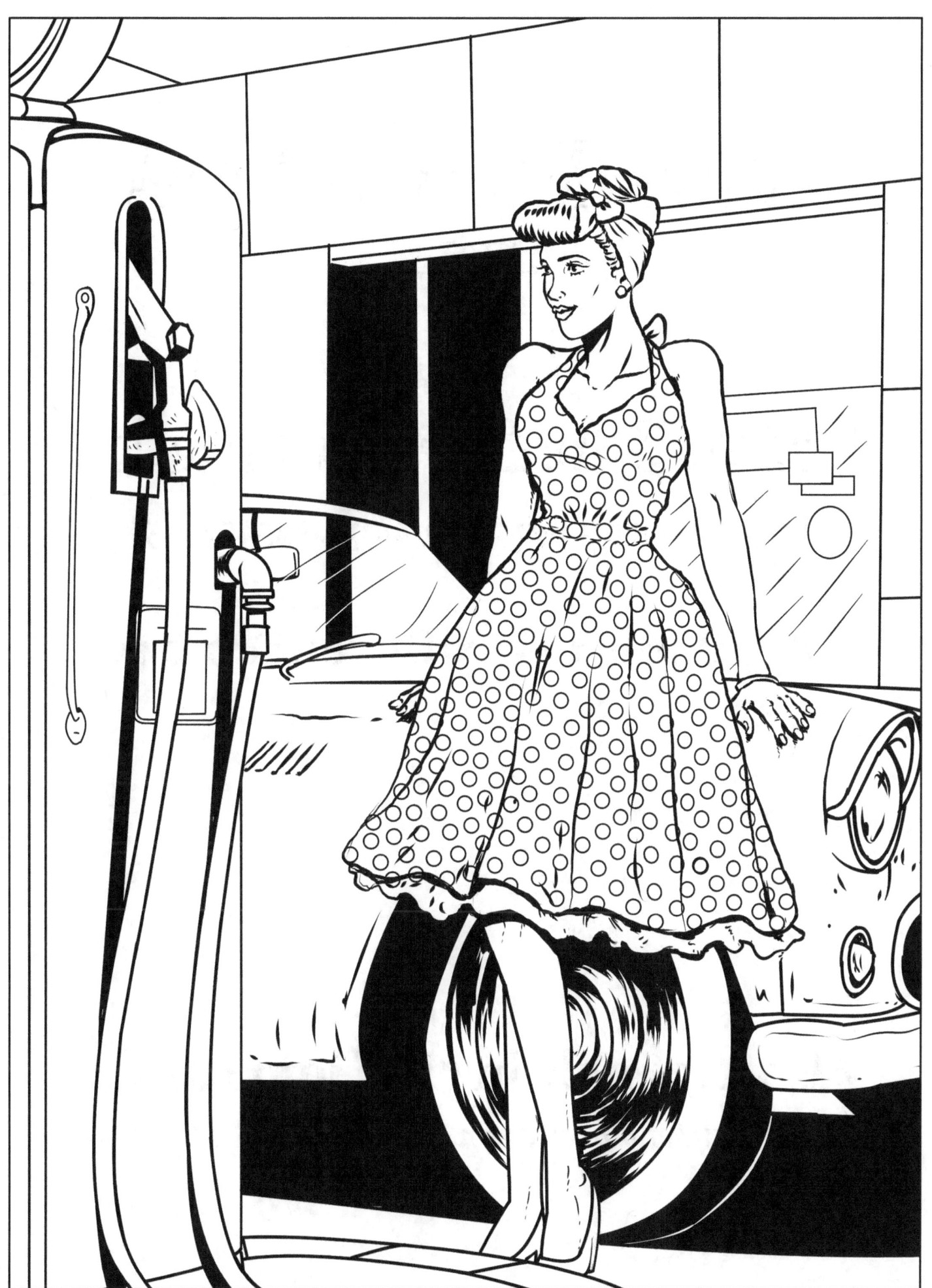

Free Bonus Page!
from:

Zen Coloring Notebook

https://www.amazon.com/dp/1535457015

Available in 9 different colors!

Also available in 5x8" journal size

https://www.amazon.com/dp/1535540591

www.ingramcontent.com/pod-product-compliance
Lightning Source LLC
Chambersburg PA
CBHW060005230526
45472CB00008B/1951